# AUSTRALIAN NAIVE PAINTERS

# AUSTRALIAN NAIVE PAINTERS

Bianca McCullough

**HILL OF CONTENT**
Melbourne

First published 1977
by Hill of Content Publishing Company Pty Ltd
86 Bourke Street Melbourne 3000 Australia

© Copyright Hill of Content Publishing Company Pty Ltd 1977

Design and production by Barbara Beckett and Ian Green & Associates
Filmset by T.P. Graphic Arts Services Hong Kong
Printed in Hong Kong by Dai Nippon Printing Co (HK) Ltd

National Library of Australia
Cataloguing-in-Publication data

McCullough, Bianca, 1928-.
  Australian Naive Painters

  ISBN 0 85572 081 6

  1. Paintings, Australian – Pictorial works.
  2. Paintings, Modern – 20th century – Pictorial works.
  3. Primitivism in art.   I. Title.

759.994

To
Nathan and Zwergerl

# FOREWORD

The appreciation of the work of the naive painter is largely a phenomenon of late nineteenth century taste in Europe. To a great degree it resulted from the post Impressionists' rejection of the classically based aesthetic which had dominated European art since the fifteenth century. Efforts to revitalise Western Art led the most advanced artists of the period to seek out the art of primitive and little known cultures, notably Africa and Japan, which had created powerful and expressive forms quite distinct from those familiar in Western Art.

The desire to discover new and meaningful forms, both artistic and social, became such a pervasive attitude that suddenly it was possible for a naive painter such as the *Douanier* Rousseau to be given serious critical attention despite his apparent disregard for the canons of neo-classical taste. The advanced artists of the period – Matisse, Van Gogh, Kandinsky and others – rejected the three-dimensional and naturalistic in favour of the symbolic and expressive. It was these very qualities which they found in Rousseau's work and which made them regard it so highly.

The term 'naive' which we use to describe this work creates problems of appreciation since it suggests the presence of certain qualities which are often absent from the work itself. *The Oxford Dictionary* defines 'naive' as 'natural, simple, unaffected, artless', but our use of the word 'naive' to describe this form of art tells us more about our response to the work than about the work itself. The undoubted fascination exerted by naive art springs from our sentimental desire to locate some pure and innocent land, simple and uncorrupted, in which the realities of our sophisticated urban existence have no part. The work of the naive artists allows us to impose these attitudes upon it and to value it for reasons quite different from those of its creator.

In approaching the work of the naive artists, we must keep clearly in mind that their work, like that of any artist, finally succeeds or fails because of its quality. The odd and ingenuous

aspects of such painting may provide us with secondary areas of appraisal, but the primary questions can only be those of aesthetic merit. We must distinguish between the genuine folk artist, the naive artist, the *faux-naif* and the simply incompetent for whom painting provides a therapeutic hobby, but whose work is of no critical interest.

The naive artist participates to a very large degree in Picasso's attitude to creation, 'I make objects the way I imagine them, not the way I see them', although it is also true that the very aspects of this art which we appreciate most are the aspects of work which the naive artist struggles most to eliminate. The curious drawing, the unreal perspective, the often strange relationship of element to element are, at times, the result of lack of training and skill and not of intention. In the main, the work is the creation on canvas of past events, presented not so much as these looked at the time, but as they have continued to exist in the artist's imagination.

There are, of course, wide variations in approach among the naive painters. For some the subjects chosen are drawn entirely from imagination and, as in the case of Rousseau, they depict some romantic, visionary world far removed from the banalities of everyday existence. For others the intention is to record a remembered or immediately observed reality with an intensity of vision which lifts it to a new plane of meaning. A third group manage to fuse aspects of daily life with elements of fantasy, to produce an art bordering on the surreal. However, in every case the work is the result of a subjective approach which, oblivious of stylistic consideration, attempts to present the chosen subject with absolute fidelity and in exact detail. The best of these artists produce work which springs from a world-view which is essentially simple, but their ability to co-ordinate the artistic elements into an overall rhythm is no less for that. In many cases the lack of technical skill is not a positive virtue, as we tend to interpret it, but an obstacle the artist strives to overcome.

In Australia, art has been, and to a large extent still is, a colonial art responding to directions and styles established

in Europe and, more recently, in the United States of America. Rather than look to and build upon the art of the indigenous population, our artists have continued to echo the metropolitan modes and so prevented the growth of a uniquely Australian art, an art with something more to offer than gum trees and distant vistas of sunlit plains and blue hills. Perhaps the naive painters presented in this book, through their passion for the psychologically and conceptually true, can assist the non-naive artists of our country to a perception of their physical and mental environment and to the creation of a new and distinctively Australian approach.

<div align="right">Graeme Sturgeon</div>

# ACKNOWLEDGEMENTS

I should like to acknowledge with thanks the help of the following:

*Private Collectors*, Nathan Beller, O.B.E., Marszena Birnberg, Anne Graham, Pro Hart, M.B.E., Pat Kennison, Dr W. Orchard, Clifton Pugh and Judy Seebacher.

*Galleries*, Gallery A, Sydney, New South Wales, the Australian Galleries, Melbourne, Victoria, Kurt Barry Galleries, Surfers Paradise, Queensland, the Benalla Art Gallery (Audrey Banfield), Benalla, Victoria, the Bartoni Gallery, Melbourne, Victoria, the Darling Downs Gallery, Toowomba, Queensland, Christopher Davis Antiques, Sydney, New South Wales, the Rudy Komon Gallery, Sydney, New South Wales, the Rustic Gallery, Melbourne, Victoria, the Sydenham Gallery, South Australia, the Toowomba Art Gallery, Toowomba, Queensland, Barry Stern Galleries, New South Wales, and the Artarmon Galleries, New South Wales.

Most of the photographs of the works reproduced in this book were taken by Peter Hill of Main Beach, Queensland, John Edson of Melbourne, Victoria and Robert Walker of Paddington, New South Wales.

To all those, too numerous to mention, who kindly helped me in my research, many thanks.

*Bianca McCullough*

# CONTENTS

# INDEX

| 56 | **Muriel Luders** | *Sullivan's Lagoon, Tarrafandra* Collection of Galley A, Sydney. |
| | | *Old Oaks, Tumut River* Collection of Gallery A, Sydney. |
| 58 | **Ellen Maloney** | *Noah's Ark* Toowoomba City Art Gallery Collection. |
| | | *Rangeville – Toowoomba* Collection of B. McCullough. |
| 60 | **Rae Marks** | *The Late Night Read* Private Collection. |
| | | *The Swimming Pool* Private Collection. |
| 62 | **Mirka Mora** | *Dolls* Collection of Marzena Birnberg. |
| 64 | **Ross Moore** | *Fishing* Collection of the artist. |
| | | *Nora on the Sofa* Collection of the artist. |
| 66 | **Sue Nagel** | *Outback Cricket* Private Collection. |
| | | *Picnic Race Meeting at Wilcannia* Private Collection. |
| 68 | **Dick Roughsey** | *Women Decorating for Initiation Ceremony – Mornington Island* Collection of Barry Stern Gallery, Sydney. |
| 70 | **Hugh Schulz** | *Emus* Collection of the artist. |
| | | *Ayers Rock* Collection of the artist. |
| 90 | **June Stephenson★** | *Flowers for the Angels* Collection of the artist. |
| 72 | **Eric L. Stewart** | *Legend of Everlasting Water* Collection of Clifton Pugh. |
| | | *The Fire Bird* Collection of Clifton Pugh. |
| 92 | **Percy Trezise★** | Title not known Collection of Kurt Barry, Queensland. |
| | | *Sandstone Peaks on Kennedy Creek* Collection of Artarmon Gallery, Sydney. |
| 74 | **Milan Todd** | *Expectations – Carving in Queensland Beech* Collection of the artist. |
| 76 | **Selby Warren** | *Gold Mining* Collection of Rudy Komon Gallery, Sydney. |
| | | *Untitled* Collection of Rudy Komon Gallery, Sydney. |
| 94 | **Maynard Waters★** | *Prayers on the Murray* Collection of N. Beller. |
| 78 | **Max Watters** | *View from Lemington Road* Collection of Frank Watters Gallery, Sydney. |
| | | *House with Tanks, Antiene* Collection of Frank Watters Gallery, Sydney. |
| 80 | **Bill Yaxley** | *Dingo in Paradise* Collection of the artist. |
| | | *On the Way to Andy's Place* Collection of the artist. |

★An *asterisk* indicates those artists who have been classified as *border line cases* by the author for the purposes of this book.

# INTRODUCTION

There is currently a world wide interest in naive art. It is
generally assumed that this is a reaction against over-civilisation,
intellectual saturation in all art forms, and a subconscious
longing for the simple pleasures of life.

After all, our sensibilities are being assaulted with misery,
disaster and violence from the moment we turn on the early
morning radio news, to the last abrasive television film at night.
Since good news does not sell newspapers and simple things
are rarely considered worthy of media attention, we might
sometimes have to sneak a clandestine look at a world of
unsensational pleasures. If we find it hard to keep our own lives
simple, at least we can participate in someone else's attempt.

These are some, but by no means the most important reasons
for the sudden preoccupation with naive art forms.

Humanity as a whole, and in every field, is slowly retracting
its gods and demons, dogmas and fashions, those artificial
projectiles which, at the outset of a precarious journey through
the centuries, peopled an alien world. Now, beneath the air-
conditioned clutter, it has rediscovered with astonishment a real
world of plants and beetles, life and joy – a world which has
survived in spite of years of hibernation.

We have progressed sufficiently to see the futility of constant
acquisition, of hoarding chattels which turn into chains.
We have suddenly become aware of an independent source
of happiness in natural events – 'A loaf of bread, a jug of wine
and thou...' translated, as it was meant to be, into basic food,
simple fun and enjoyable curiosity about the people around us.
This is the old-new message preached by the gurus of an
Aquarian generation.

A hundred years ago Rousseau dared to picture what he saw
in nature without translating it into painterly conventions.
Whereas he had been considered 'way out' then, the quest for
a return to nature has now become world wide. It includes
governmental blessing on sport and recreation, a revival of herb

medicines and organically grown food and acceptance of yoga as a valid form of all round prophylaxis.

Naive paintings echo a self-assurance and intensity of awareness which parallel the writings of Hesse, Huxley and Castaneda. But not everyone has the chance, or the time, to engage in such heady reading. Within our modern life style reading has become a luxury reserved for those times when we have enough leisure, such as holidays. In a world which is geared to instant living – instant coffee instead of freshly ground beans, instant soup replacing a basket of fresh vegetables, instant culture straight from television, instant music from FM radio – the immediate reaction to a windowscape of basic issues is a feeling of great joy.

Naive art is such a windowscape. Through the eyes of the painter we confront an unadulterated version of an orderly world in miniature which often has the atmosphere of a picture book. The visual language of naive painting is universal and neither semantics nor habitual responses get in the way. There is instant rapport.

*Reactions to Naive Art*

I have often watched people's first reaction to naive art. This reaction is always strong, either negative or positive. In general the onlookers fall into two distinct groups, independent of age except for very young children. Young children identify immediately and completely because they are as yet unhampered by aesthetic conventions and are gifted with the same lucidity as the artist. The more we learn in life, the less we retain of this starkness of vision which is the birthright of the child, the saint and the naif.

The first group dislikes violently what they see. Intellect and reason reject the technical mistakes of perspective and colour treatment, although composition is rarely an issue. It seems that by recording nature in the raw, nature takes care of composition anyway. Pro Hart once pointed out to me that a painter need never improve on the natural kaleidoscope of colours in a

crowd of people. Somehow, the red coats and green hats and blue umbrellas happen to be in just the right juxtaposition, relative to the entire composition. It is best to record them as they are.

For some, however, the childish subjects of naive paintings may be an infringement upon a carefully buried sentimentality, or the clear cut divisions between good and evil in mythical and religious paintings may become a danger to sophisticated moral codes. The very simplicity of statement shakes the defences built up against a world of haste and mass production. People who react negatively to naive art can generally be relied upon to regard as alien every natural element which interferes with the creation of their technological demi-gods. They hate to be reminded that outside their concrete fortresses lies an elemental world which is complete in itself. This completeness from which springs all the beauty, as well as all the enormous destructive forces of wind, water, sun and tides, shows us the frailty and incompleteness of our technology. You only have to stand at the edge of a reservoir to shudder at man's audacity to set toy-like barriers of stone and steel against a valley full of water. On a smaller scale, look at the tombstones in a country graveyard which have been split by a relentless blackberry plant. It is a pity that we have been so thoroughly conditioned to see only commercial possibilities in the abundance of life.

The second group respond to the naif's clear-cut statement with equally clear-cut understanding.

Their reaction is immediate, like eyes meeting in a crowd, like a tune which strikes a common chord inside us and makes us happy. Generally, it is easier for the amateur to identify with this art form than for the expert. The habit of cataloguing works of art by comparison with already historically sanctioned art forms, does not allow enough flexibility for intuitional acceptance.

*Naive Art is*

Before dissecting naive art in order to classify and explain its

appeal to millions of people around the world, let me give you my own *naive* version.

Naive art simply *is*. Everything else becomes an exercise in pretty words and clever phrases. A naive painting is like a summer meadow, a kaleidoscope of colour and growth, movement and perfume, earth and sky – and life in between.

I do not sit down to assess whether the grass is too tall or too green, whether the flowers blend in and are suitably spaced. I stand – breathless – before the total impact and I open myself to it without qualification.

Saint Augustine, when asked to explain the quality of time, replied, 'As long as no one asks me to explain, I know. But if you question me, I do not know'. Does this not also apply to naive art? Perhaps it might be easier to say what this art form is *not* than what it *is*.

Certainly, naive art is not just amateur painting and most 'Sunday Painters' would not qualify. Naive painting has no strict guidelines.

It cannot be explained as a definite direction in art, for it acts rather as a tributary to the mainstream of modern art. Although it is timeless, it is influenced by present day issues as they affect the painter.

Unlike formal painting, which falls into international time governed patterns, it cannot be classified into 'schools' because the individual artists need neither intellectual stimulus nor models for their work. None of the naifs would want to be either teacher or pupil because both the impulse to create and the execution of the work are dictated by personal confrontation.

*I believe that the terms 'naive art' and 'primitive art' are not interchangeable.* Primitive art contains tribal and ethnic symbolism in carefully structured patterns and is without the spontaneity of the unselfconscious naif. The primitive painter, like the early builders of churches (Freemasons), is a highly trained craftsman and philosopher who works within a rigid *shorthand* to record and preserve a racial culture.

In music you might compare a folk tune to naive art and a

Gregorian chant to primitive art. Pre-Columbian, Aboriginal, African and Polynesian tribal art belong to the category of primitives.

*Australian Naives*

Although one can find regional groupings of naive art in, say, Broken Hill or Southern Queensland, the proximity of style comes from a similarity of life styles such as with miners or farmers, rather than from artistic deliberation. The vastness of Australia suits the individualistic naif. The deep silence of its harsh outback, which compels even casual visitors to acknowledge its spirituality, leaves its full impact on the receptive soul of the instinctive painter.

Initially naive artists work in anonymity, content in the fulfilment of their task. Once discovered, however, their style is quickly classified by outsiders and *retrospectively* labelled for identification. It is at this stage that regional similarities become apparent, but discernible only through a process of deliberate dissection and comparison. Left alone, the work of the naive painters simply *is* like the beauty they so tenderly portray.

Australia's population has its racial origins in many varying cultures. Although the painters represented here have lived most of their lives in this country, they have carried over into their work a style reminiscent of their background. In Fardoulys' work, we often find Greek undertones, Perle Hessing draws her inspiration from Jewish mythology and David Fielding's little houses relate to his architectural family background. Certainly, spontaneous local art must reflect certain regional peculiarities, whether they be the colouring of a landscape, the dress and implements of the people in it, or the recording of ritualistic events.

Just as we see in the paintings of Italian naifs a recurrence of clerical figures in cassocks and wide black hats, so we find tent riggers, gold diggers, bushrangers and miners in Australian pictures. These people form the matrix of our society, which has drawn strength and inspiration from their way of life and

their legends. The legends live on in the hearts of the outback people who furnish us with most of the naive artists.

Animals figure largely in naive pictures, probably because a love of nature includes a love of both wild and domestic creatures. In Australian paintings we find typically Australian animals – dingoes, emus, kangaroos and rabbits. If we look closely at them, their expressions are almost human and there is no portrayal of danger or dislike. Sam Byrne's *Rabbit Plague* paintings are those of an amused observer, not a hunter. Yaxley's dingo actually rates his own paradise.

*How Genuine is this Art Form?*

Because of the great appeal of naive art the temptation exists for exploitation. Any average commercial artist could turn out reasonable illustrations in the naive style, yet these would lack the immense charm and radiance which a truly spontaneous painting exudes. Much has been made of the *childlike* quality in naive painting. It is a confusing term and might better be changed to *innocence* as a counterpart to the worldliness of which we are so proud. Spiritual humility, unlike humility in action, cannot be cultivated; it is the outward manifestation of the wisdom we associate with sages, and children.

The difference between genuine and contrived naive art lies not in the application of paint to canvas, but in the dedication which went into creating it and in the intensity of feeling which prompted the act itself.

Heritage and tradition entail such intensity and account for the regional aspects of many paintings. Men like Sam Byrne, who have spent their lives in mining towns, know every tiny facet of that life, every wheel in the machinery called Broken Hill. They translate this knowledge instinctively into their compositions. An outsider, attempting the same composition, could only copy existing work, or study *intellectually* those aspects which are the natural heritage of the miner. Such total involvement cannot be faked.

Naive painters usually work very slowly, completing few

paintings in a whole year. Those people entrusted with handling such pictures, as agents between artist and public, should recognise this fact and resist the temptation to speed up production to satisfy a market.

The naive painters of Europe have been called painters of the religious heart, using the term 'religious' to mean uncritical awareness, not adherence to a dogma. They have also been called instinctive or innocent painters because their artistic output depends upon impulse and not upon intellectual design. There is a danger of losing this impulse when years of practice bring technical perfection and public recognition tempts the artist into repetition. The paintings and carvings then increase in professionalism, but decrease in their impact.

Innocence cannot be feigned. It cannot be hurried either – and an intellectual use of the 'tricks' of naive art to increase or speed up production is a contradiction which destroys the magical quality.

## Is Naive Art a Women's Prerogative?

Women make up a high percentage of naive artists. While feminists object to women being labelled intuitive and instinctive rather than intellectual, it is this undoubted bias towards spiritual qualities which lends magic to the paintings of women naifs.

Introspection is a particularly feminine trait, since the physical and spiritual nature of woman has equipped her to *absorb*. She has been called the ear of God in ancient scriptures – absorbing wisdom – and assigned the role of teacher and perpetuator of tradition to the race. She excels at sentimental documentation of weddings and family rituals. Perhaps, unlike men, she is not ashamed of her sentimentality which she uses to bring colour into her everyday life. Her pictures are often hardly more than a memento – a pressed and fragile forget-me-not within a frame.

Girls have more chance than boys to retain their childhood world of fantasy. The pressures to become practical and

self-sufficient are generally not as strong and the herd instinct is not as critically developed. Young mothers, attuned to their children's world, recreate and thereby refresh their childhood dreams and in this way never lose them. The toy-like scenes of Roma Higgins and the mysterious gardens of Sister Dorothy, as well as the dolls of Mirka Mora, are illustrations of this point.

It has never been stressed enough that *tenderness* is an important quality in naive painting. It shows in many ways; in the outline of a little black dog or the quite motherly portrayal of Mathilda Lister's bushrangers, who look like naughty boys on horseback in need of a maternal scolding.

It is an immediate, instinctive, uncritical love for animals and plants, children and old folk, which provokes the inquisitiveness of women painters. They often live away from the main cities in outback areas where they need to rely on their inner resources or succumb to self-pity. Even the city based artists usually have a history of isolation and self-reliance. Because of it, or in spite of it, they retain that instant curiosity and openness of the tenderly innocent observer.

## Is Age Related to Naive Painting?

A large number of naive painters seem to be middle-aged or well advanced in years. Sam Byrne is in his nineties, and so was Fardoulys when he became famous. It applies to Charles Callins and Selby Warren and many others. It might make an interesting psychological study to equate such ages with the happy temperament of the naif, but, for the moment, let us just query the assumption that only older people paint in this style.

I believe the direct relation lies in the comparatively short time during which naive painting has become legitimate. Twenty years ago it was still possible to buy cheaply the famous Yugoslav glass paintings of Generalic and Rabuzin which now sell for thousands of dollars – and to be considered eccentric for collecting such work.

In Australia the interest is even more recent, and only a very small esoteric group of collectors is concentrating on naifs.

Therefore, there are many painters, like Sam Byrne and Charles Callins, whose work never reached the popular art market until they had been painting for decades. Certainly, by academic standards, they were late starters in their artistic careers; but since most of them had strenuous jobs which filled their early years, painting had to take second place as a hobby. In many cases early work was destroyed or painted over to economise on materials.

In the case of women painters, their early years are usually occupied with raising families. Painting remains a luxury to be taken up when the children are independent and the family is economically more secure.

Since starting on this book, and actively researching naive art in Australia, I have come across a number of younger, and some very young, artists for whom this is the only possible form of expression.

*Innocence Versus Commercialism*

Few people, and certainly no art dealer, would believe the fairy-tale about naifs working blissfully unaware of their potential or the commercial value of their work. Beneath the happy, childlike gaze of the naif beats a similarly basic trader's heart which substitutes the childhood marbles for commercially viable picture subjects.

There is no discrepancy here, provided the middle-men do not succumb to the temptation of over-promoting their product for the sake of quick profit. It is an established fact that art is a commercial commodity, which is produced, traded and invested in, like any other commodity. But, unlike sausages or hardware, it is a living thing and must be handled with respect.

I believe that in Australia, more than anywhere else in the world, there is still a chance to discover painters who remain firm individualists and truly unspoilt by success.

In 1964, Daniel Thomas, who was curator at the Art Gallery

of New South Wales and an art critic for the Sydney Sunday Telegraph, was judging the Tumut Art Exhibition and came across the work of Muriel Luders, whose painting he bought. Her work appealed to many people, but some *experts* panned it. They described her paintings as being mere copies of the paintings of America's famous Grandma Moses. To settle the dispute it was decided to borrow one of these very valuable American works, bring it to Australia under strict security precautions, and set it side by side with Muriel Luders' paintings. Daniel Thomas even asked Mrs Luders to come to Sydney and see for herself. After much deliberation and comparison it was agreed that the Australian work was unique and any similarity was one of attitude rather than plagiarism.

Donald Friend and Clifton Pugh have each discovered naive painters who later became well known. Mathilda Lister was Donald Friend's neighbour at Hill End, when he discovered her potential and encouraged her to paint.

Eric Stewart was less fortunate. He had worked all his life in the outback, sometimes as bricklayer, Post-Master-General's Department employee, even as a butcher. When he died in 1970 he had never exhibited his paintings and no one might have known the colourful, naive versions of Aboriginal legends, had Clifton Pugh not come across forty-five of them in a second-hand shop in Echuca. The proprietor had bought them as a job lot at auction and was about to throw them out. Pugh bought fifteen of them. In 1972 the Chapman Powell Gallery in Melbourne staged an Eric Stewart exhibition which generated great interest from the press and public. Since then his paintings have become collectors' items and he serves as a prime example of a naif who worked all his life in anonymity before a chance encounter brought his name before the public.

# THE AUSTRALIAN NAIVES

The following illustrations will elucidate much of what has been hinted at. However, in establishing a demarcation line for naifs, I found myself touching other – established – types of painting which naturally overlapped these indefinite boundaries. For this reason I have included a chapter on *border line cases* which inclusion, however small, will serve as stimulus for further research by the reader.

# HENRY BASTIN

Born in Belgium in 1896, Henry Bastin arrived in Australia in 1920.

Like many naifs, he led a colourful and varied life. He worked with a camel mail service between Broken Hill and South Australia and later went to Western Australia to work.

Moving to Queensland, he became an opal miner and it was there, on the opal fields, that he started to paint in the 1950s. Materials were not readily available, but he overcame some of his difficulties by making his own brushes out of the hairs of horses' tails. The art of improvisation came easily to him after so many years in out of the way places.

Henry Bastin staged his first two exhibitions in 1958 at the Melbourne Museum of Modern Art. Since then he has become well known and his work is now the highest prized of that of all the naifs.

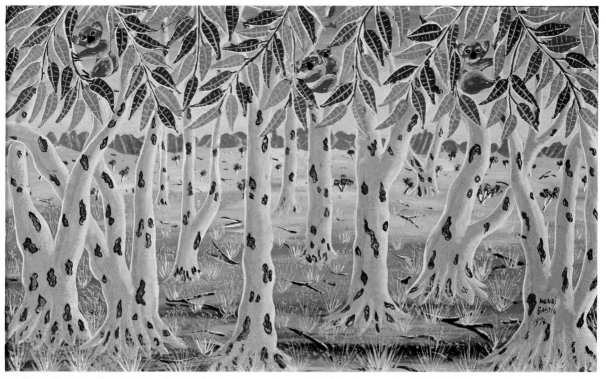

*Koalas* Collection of Kurt Barry, Queensland.

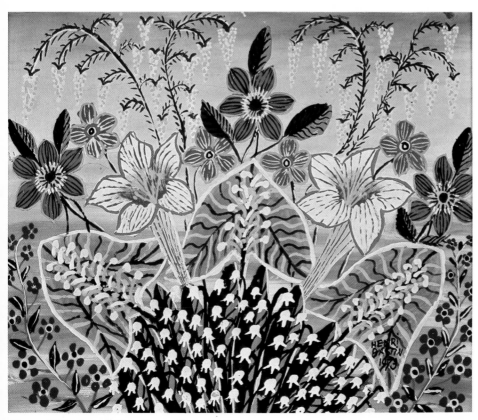

*Flowers* Collection of Kurt Barry, Queensland.

# OSWALD BLAIR

Born in Tenterfield, New South Wales, in 1900, Oswald Blair
is an artist who has tried his hand at many tasks besides painting.

His varied career began early. At the age of twelve he became
a builder's helper and then a tailor's shop-hand. At sixteen he
was apprenticed to a baker and he worked in this trade for the
next twenty years.

In the 1930s he became restless. The call of the Australian
bush was strong and he set out to work as a station hand,
kangaroo shooter, ring-barker of trees and scrub cutter. He
travelled through the far north of New South Wales, to
Coopers Creek in South Australia and to Queensland before
settling down in Sydney.

In Sydney Oswald Blair worked as a public servant until his
retirement in 1967. It was after he had retired that he started to
dabble with paint and brush and eventually found his own
unique style.

His paintings have been hung in the Wynne Prize section of
the Art Gallery of New South Wales at the annual showing of
Archibald, Wynne and Sulman prize winners. They have
appeared also in the Sydney Royal Easter Show Exhibition and
numerous other exhibitions.

Oswald Blair's paintings have been acquired by public and
private collections and one of his works hangs in the National
Gallery of Victoria. Christopher Davis Antiques handles his
work in Sydney.

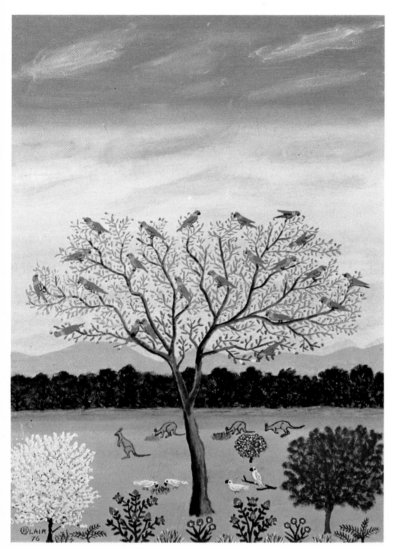

*Birds Feeding in Tree* Collection of the artist.

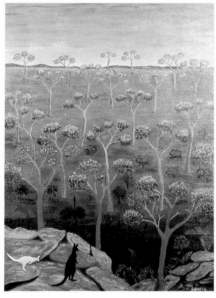

*Sunrise on Iron Bark Country* Collection of Christopher Davis Antiques, Sydney.

# SAM BYRNE

Sam Byrne was born in 1883 in the Barossa Valley in South Australia. He was discovered by Len French.

After working as a miner in the Broken Hill silver mines most of his life, he started painting seriously at the age of seventy-three.

His first pictures showed historical events and views of Broken Hill. His later works record facets of his own working life.

Sam Byrne is now ninety-four years old and his eyesight is weakening. As a result, his later paintings have taken on a certain abstracted quality; however, the strong vibrant colours which have always marked his work remain.

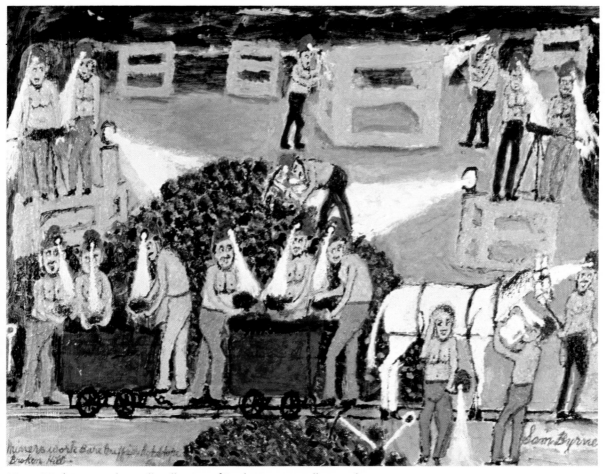

*Miners Work Bare, Broken Hill* Collection of Rudy Komon Gallery, Sydney.

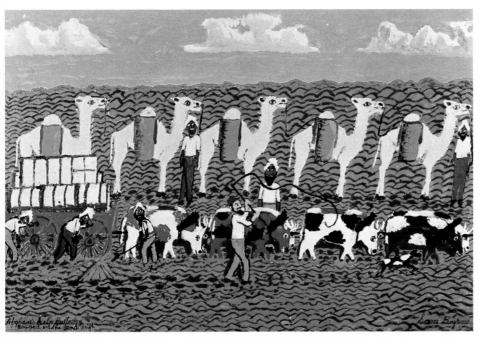

*Afghans Help Bullocky Bogged in the Sand Drift* Collection of Rudy Komon Gallery, Sydney.

# CHARLES CALLINS

Charles Callins was born in Queensland in 1887.

He worked for many years in printing offices. His retirement marked the beginning of his career as an artist and he did not paint seriously until 1947.

Callins spent a large part of his life sailing and fishing in waters around North Queensland. His paintings reflect this part of his life and are full of nautical memories.

He first exhibited with the Johnstone Gallery in Sydney in 1957 and from then on he exhibited with Gallery A in Sydney.

Gallery A is showing a large retrospective exhibition of Callins' work to celebrate his ninetieth birthday in 1977.

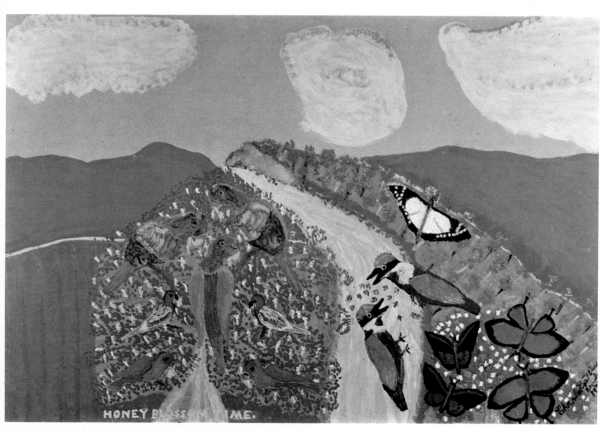

*Honey Blossom Time* Collection of Gallery A, Sydney.

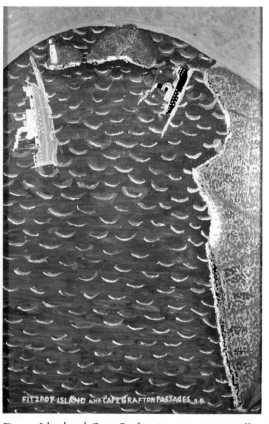

*Fitzroy Island and Cape Grafton Passages, N.Q.* Collection of Gallery A, Sydney.

# LORNA CHICK

Lorna Chick was born in 1922 at Wangandary near Wangaratta in North Eastern Victoria. She went to school in Wangaratta and since her marriage has lived on a farm at Wangandary.

Her painting began about 1964 when she was taking her two sons to evening classes in art at the Wangaratta Technical School. Her first success came with the 1967 Fairley Art Award when her work was placed among the first five.

Lorna Chick's work is included in the Shepparton Art Gallery collection, the Wangaratta Council collection, the private collection of Dr W. Orchard as well as being included in many other less well known private collections in Australia, New Zealand, America and London. Her most ambitious work is a ten foot by four foot canvas acquired by the National Gallery of Australia in Canberra in 1976.

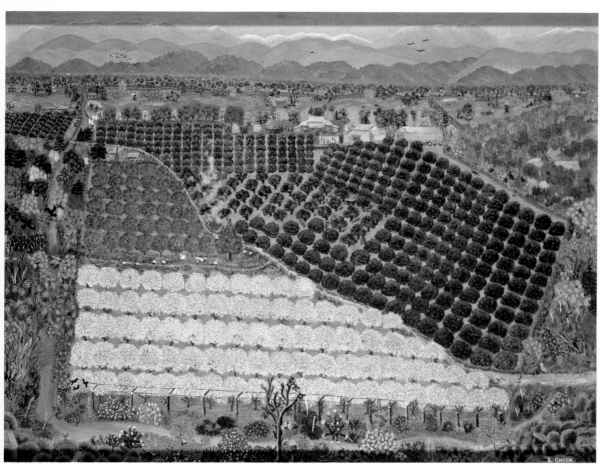

*South Wangaratta* Collection of A. Graham.

# CHARLES FREDERIC COLE

Born in 1875 of Kentish immigrant parents, this artist died in 1959.

He worked as a chief orchard inspector for the Victorian Department of Agriculture and the King Cole Apple was named after his family by him. He wrote books on the propagation of fruit and garden trees, especially the walnut and hybridised camellias. He illustrated his own books and it is his experience in this field which accounts for his intricate and life-like flower paintings. It was his habit to measure each of his flower subjects with a ruler in order to get a precise image.

As an artist he was untaught, but Charles Frederic Cole painted during most of his life. His subjects were often imaginary and were inspired by the stories he heard from people while travelling around Victoria in his capacity of orchard inspector.

He was also a keen bird watcher, published articles in *Emu*, the magazine of the Royal Australian Ornithologists Union, and became well known for his discovery that the white and black backed magpie and its slightly different cousin were one and the same species.

In his paintings he frequently used metallic colours which he obtained by grinding bronze and copper and mixing the fine metallic grains or dust with his normal painting medium.

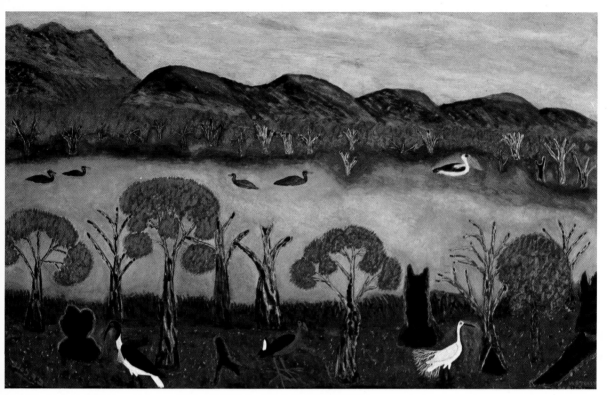

*Winton Swamp — Benalla* Collection of C. Sanders.

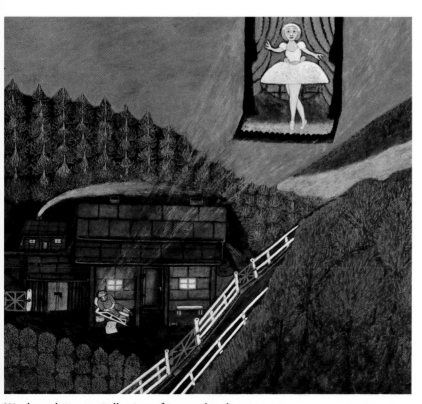

*Woodcutter's Dream* Collection of L. van der Sluys.

# SISTER DOROTHY

Sister Dorothy was born in Swan Hill in Victoria in 1920. She attended the local school until she was sixteen when she went to continue her education at Genazzano Convent in the Melbourne suburb of Kew.

Although artistic, she decided against a career in art because she felt it was too Bohemian and unremunerative.

While at Genazzano as a student, she decided to enter the Convent and make teaching her life. She joined the Faithful Companions of Jesus and soon used her artistic talent to advantage by painting the 'Spiritual Bouquets' given to the Superior on special occasions and feast days. These small, intricate cards were painstakingly painted in water-colours.

Sister Dorothy taught art, among other subjects, at Genazzano Convent for many years. In 1972 she was moved to the Stella Maris Convent at Frankston in Victoria and there she joined the Peninsula Art Group.

In 1975 she gained her Diploma of Fine Art (Painting) at Caulfield Institute of Technology and in 1976 she was awarded the Mornington Art Prize.

Sister Dorothy's paintings are simply extensions of the lovingly composed votive cards which delighted her companions.

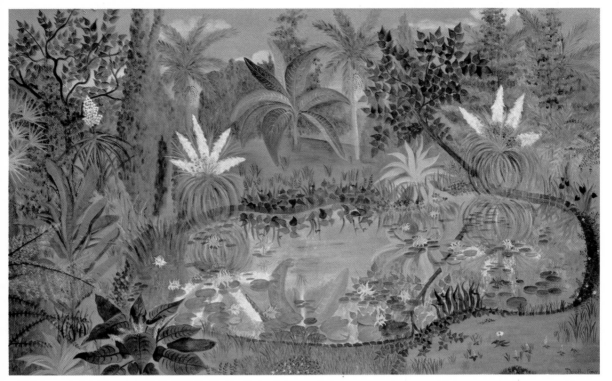

*Botanical Gardens — Falling Trees* Private Collection.

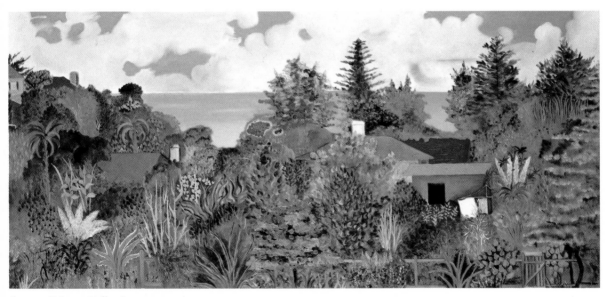

*Sorrento* Private Collection.

# JAMES FARDOULYS

Born in Kythera in Greece in 1900, James Fardoulys came to Australia in 1914.

In adulthood he travelled widely around Australia painting water holes, gum trees, horses and cockatoos. In spite of his choice of typically Australian subject matter, he seemed to approach his subjects always with the eye of a Greek.

After marrying a ventriloquist, James Fardoulys began to travel with show people, mostly in Queensland. Eventually he became a taxi-driver and retired when he was about sixty.

It was after his retirement that he began to paint seriously. He had his first exhibition in Sydney at the Johnstone Gallery in 1966. He then regularly participated in group exhibitions and won a number of prizes including the Warren Caltex Prize. He died in Brisbane in 1975.

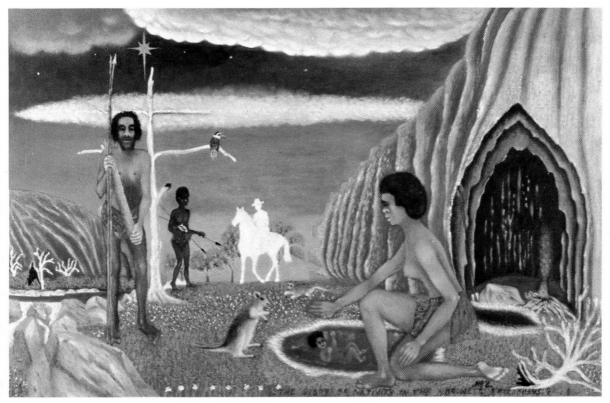

*The Story of the Nativity in the North-West* Collection of Rudy Komon Gallery, Sydney.

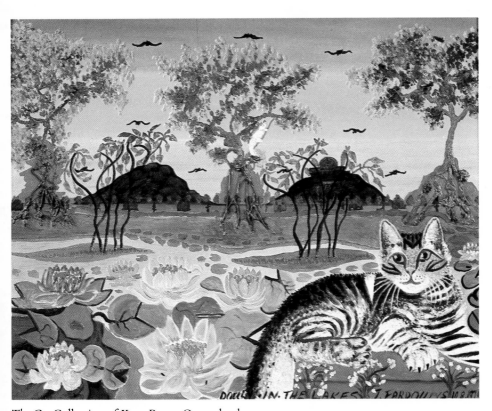

*The Cat* Collection of Kurt Barry, Queensland.

# DAVID FIELDING

David Fielding was born in England in 1944. His family left
the United Kingdom in 1950 to live in New Zealand for some
years. They later moved to Tasmania and finally the family
settled in Adelaide.

Although he attended for a term at a formal Art School,
David Fielding is a self taught artist. During his travels he
became fascinated by the quaint Victorian colonial buildings
he saw so often and these now frequently form the subjects of
his tiny paintings.

He has illustrated children's books, designed sets for stage and
television and in the 1970s he has travelled abroad, absorbing
European architecture.

While living in the ancient British spa city of Bath, David
Fielding turned his attention from drawing to painting and
model making, being inspired by the fanciful styles of the
domestic buildings. These he now portrays with humour and
a touch of satire.

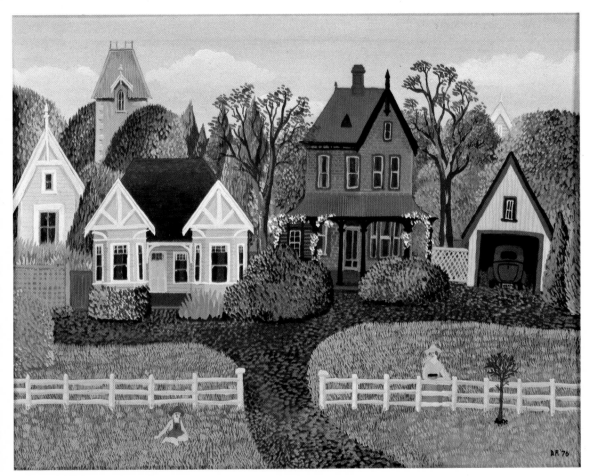

*Village* Collection of B. McCullough.

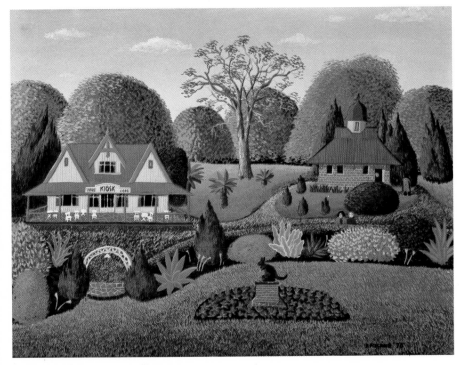

*Botanic Gardens* Private Collection.

# LIDIA GROBLICKA

Born in Poland in 1933, Lidia Groblicka graduated from the Academy of Fine Arts in Cracow, Poland in 1957.

She arrived in Australia in 1965 and lived for a time in Sydney where she also exhibited her work.

Since 1968, she has lived in Adelaide where she is a Fellow Member of the Royal South Australian Society of Artists, exhibiting mainly with the Sydenham Gallery and the Adelaide Society of Arts.

Lidia Groblicka has taken part in the Invitation Opening Exhibition of the Festival Theatre, the Master Choice Exhibition at the Festival of Arts, the Warrnambool Freemantle Exhibitions, the Print Council Touring Exhibition and a one-man show at the Australian Galleries in Melbourne.

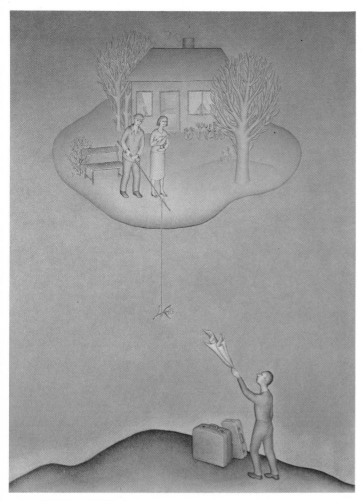

*Farewell* Private Collection.

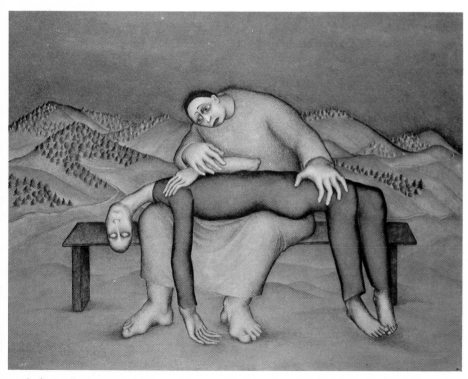

*Mother's Grief* Private Collection.

# PERLE HESSING

Perle Hessing was born in 1908 in the small Polish town of
Zaleszcyki which was once part of the Austro-Hungarian
Empire.

After racial persecution in Europe and some time spent in
Israel, she emigrated to Australia where she lived for twenty-
two years before going to England.

This artist considers herself an Australian and so does her son,
Leonard Hessing, who is a well known painter. It was he who
encouraged his mother to take up serious painting in the 1960s.
After doing so she soon exhibited in all Australian capital
cities. Her works can now be found in museums and galleries
all over the world and she has one-man shows with the Portal
Gallery in London.

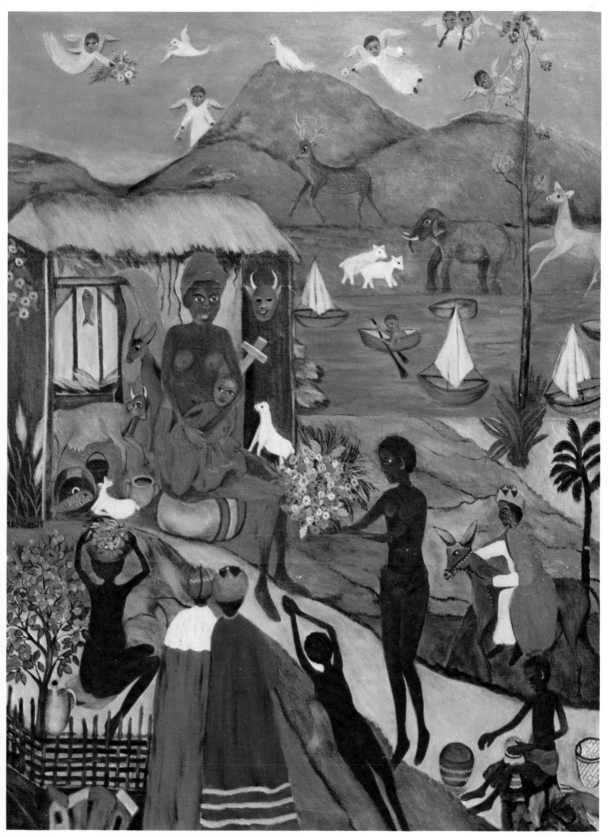

*Black Madonna* Collection of Errol E. Joyce, Queensland.

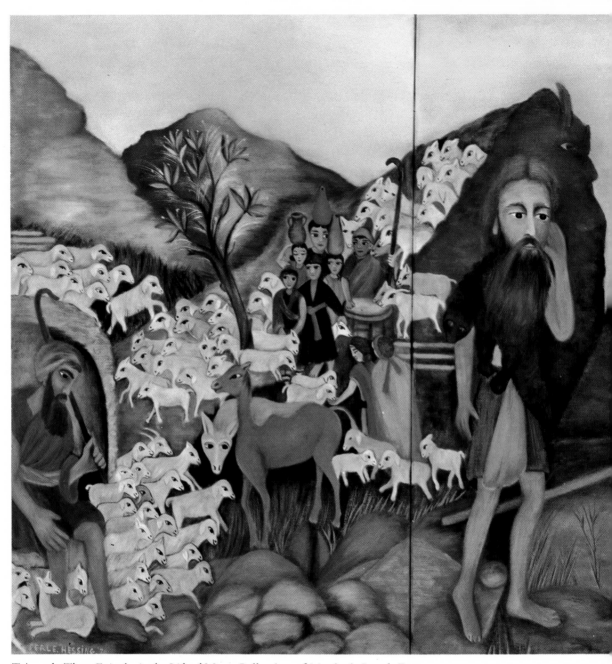

Triptych *Three Episodes in the Life of Moses* Collection of Musée de Laval, France.
Transparency kindly lent by Portal Gallery, London.

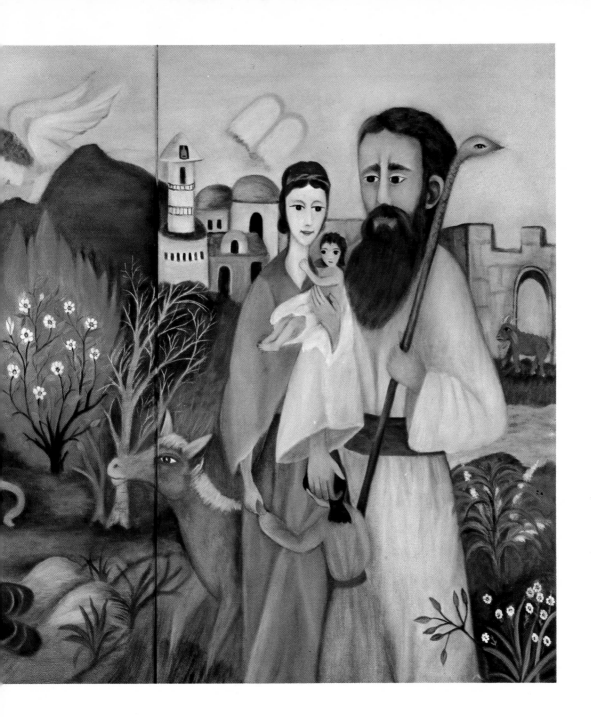

# ROMA HIGGINS

Roma Higgins was born in England in 1909 and came to Australia with her family when she was six years old.

She lived on a farm at Bangalow near Byron Bay in northern New South Wales. It was a tranquil life, full of simple pleasures – musical evenings, church fetes, picnics and weddings in the garden.

These are the subjects of her paintings and they give to her work that appeal which makes her exhibitions a sell-out and which won for her the Albury Prize in 1976.

Although she has had a few lessons, Roma Higgins is virtually untaught. Five years ago she sold her first painting; later she had exhibitions with the Bonython Galleries in Sydney and is now working towards a London show with the Portal Gallery.

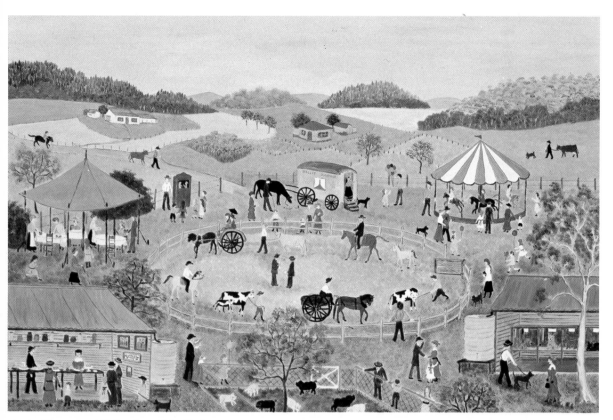

*At the Showground* Collection of A. Graham.

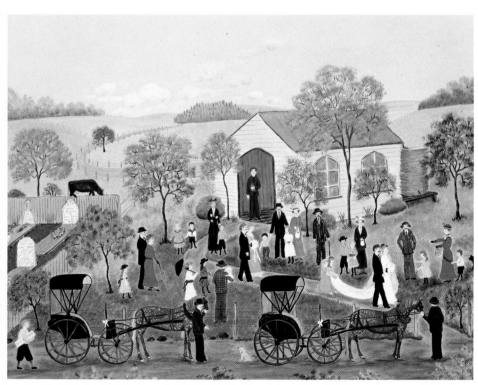

*Country Wedding* Collection of B. McCullough.

# IRVINE HOMER

Irvine Homer was born in 1919 and now lives almost a hermit life in Morisset near Broken Hill in New South Wales.

He has been called the Henry Lawson of Australian painting, recreating his early years on the cattle tracks in his *Memory Paintings*.

Initially Irvine Homer used to decorate plates and cupboards with outback scenes in the way early European peasant painters worked on wardrobes and glory chests.

William Dobell discovered Homer in the late 1950s and encouraged him to hold an exhibition in the Newcastle City Art Gallery.

He works very slowly and with infinite patience unfolds before us vignettes of Australian history which otherwise would live on only in the songs of the outback people.

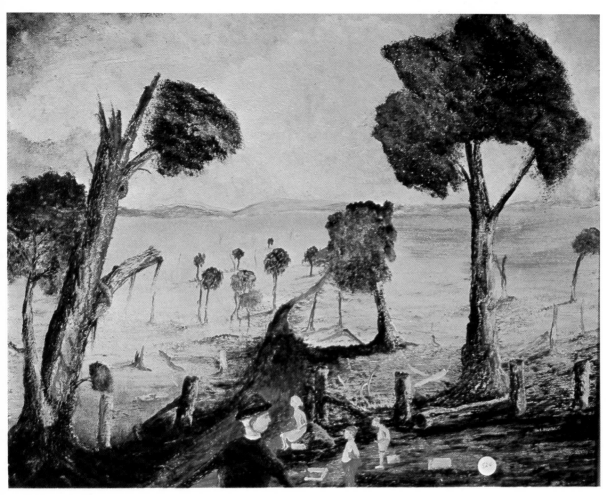

*Incabods Little Angels* Private Collection.

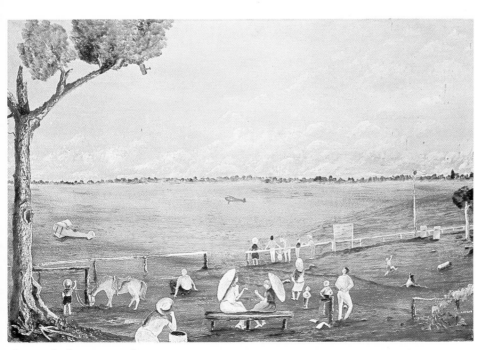

*The Daredevils* Private Collection.

# MATHILDA LISTER

Mathilda Lister was born in 1889 and died in 1965.

She was a neighbour of painter Donald Friend when they both lived at Hill End in New South Wales. He encouraged her to develop her obvious talent which eventually won her the Darcy Morris Memorial Prize and got her accepted for the Blake Prize For Religious Art competition in Sydney in 1959.

Mathilda Lister's paintings were inspired by early pioneering history and they feature bushrangers, goldminers and horsemen as well as biblical subjects.

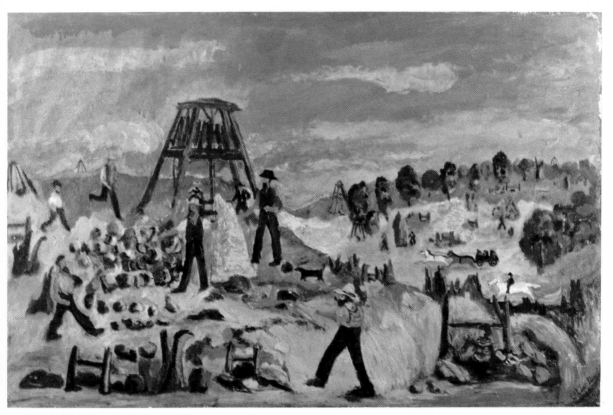

*Finding the Holdtermann Nuggett* Collection of Gallery A, Sydney.

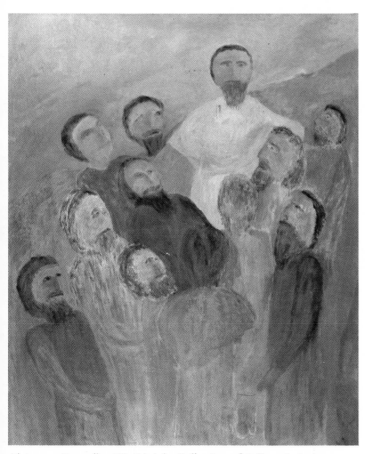

*Christ says Farewell to His Disciples* Collection of Gallery A, Sydney.

# MURIEL LUDERS

Muriel Luders is known as 'Australia's Grandma Moses – only better'.

Born in Gundagai in southern New South Wales, she is now in her late sixties. She began painting after visiting an exhibition in 1962 which she did not like very much. She decided that she could do better – and did. She entered the Tumut Art Exhibition which was judged by Daniel Thomas who discovered her and bought her first painting.

Muriel Luders is now represented in several National Galleries and many private collections, including the Margaret Carnegie collection.

Her interpretation of the Australian landscape is sensitive and delicate, without the starkness so often emphasised by our artists. Her paintings are a serenade to a world she loves and understands.

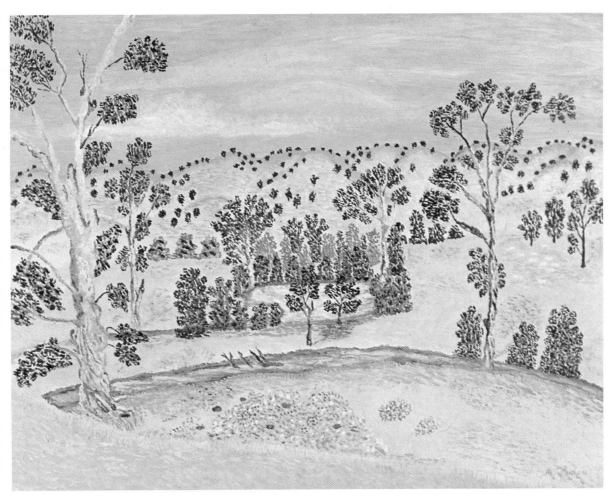

*Sullivan's Lagoon, Tarrafandra* Collection of Gallery A, Sydney.

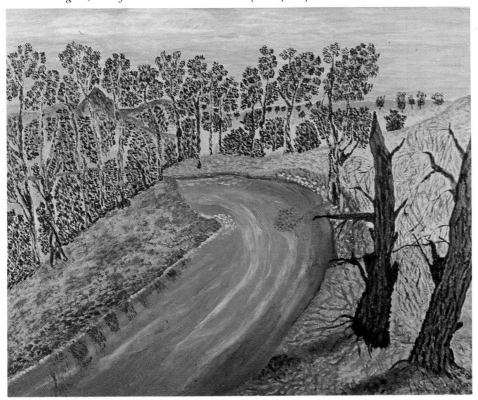

*Old Oaks, Tumut River* Collection of Gallery A, Sydney.

# ELLEN MALONEY

Born in 1900 at Toowoomba in Queensland, Ellen Maloney was always interested in drawing and painting.

As a child her family often found it difficult to supply her with art materials and it was not until the mid-1950s that she began to paint seriously. She completed an Art Diploma by correspondence course and held her first one-man exhibition at the Darling Downs Institute of Advanced Education in 1975.

Ellen Maloney took prizes in many local exhibitions and her largest painting, *Noah's Ark*, was acquired by the Toowoomba City Gallery. Her subjects were taken from the surrounding countryside and depicted the life of the people who lived around her.

Each of Ellen Maloney's paintings had its own history and for this reason she rarely parted with any of her works, preferring to remain surrounded by these various milestones of a long life. She died in 1976.

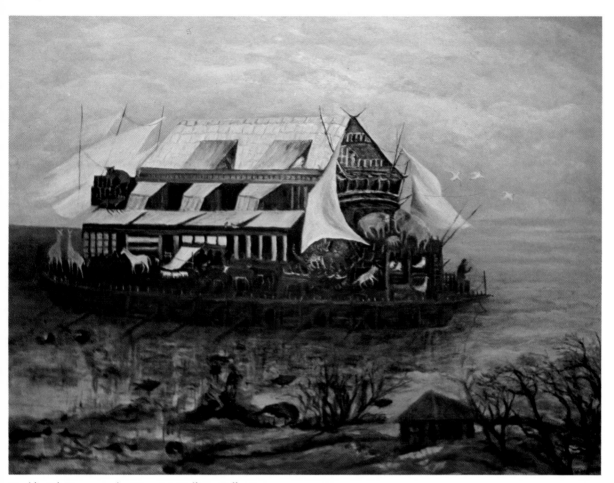

*Noah's Ark* Toowoomba City Art Gallery Collection.

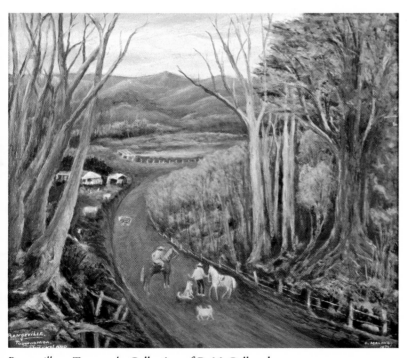

*Rangeville — Toowoomba* Collection of B. McCullough.

# RAE MARKS

Rae Marks was born in 1945. After completing her secondary education, she decided to take up art studies. She prepared for a Diploma of Art at Swinburne College of Technology in Melbourne, Victoria.

She is married and now lives with her husband and family at Eltham in Victoria.

The things that Rae Marks paints are the everyday things around her. Her pictures show people, old houses with verandas, flowers and animals. They are a lovingly constructed record of a simple life style.

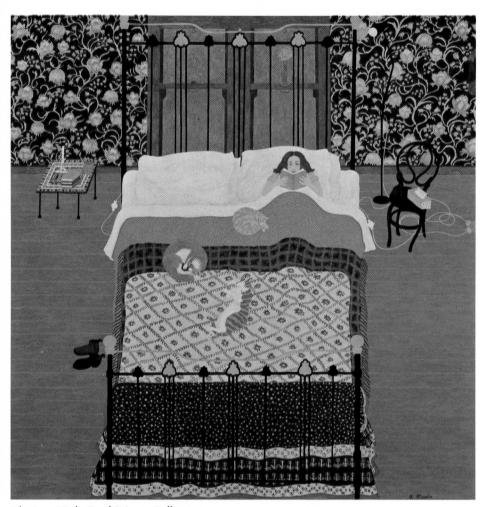

*The Late Night Read* Private Collection.

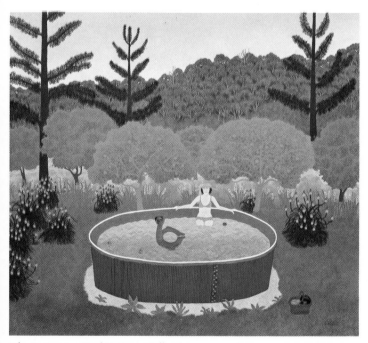

*The Swimming Pool* Private Collection.

# MIRKA MORA

Mirka Mora was born in Paris in 1928. From early childhood she was interested in painting and writing, but, instead of taking up studies in this area, she found herself going to a famous theatre school where she was taught by such legendary people as Marcel Marceau.

She married George Mora in 1947 and emigrated to Australia in 1951.

In 1953 Mirka Mora had her first exhibition of paintings in Melbourne and a year later she helped to revive the Contemporary Artists' Society.

During a personal crisis in 1970, she cut out some of her earlier drawings and discovered that they looked like three-dimensional dolls. Having collected antique dolls for a long time, Mirka Mora now started to create her own mythical creatures, painting their bodies as well as their faces.

Since this extraordinary beginning, Mirka Mora has had a number of one-man 'doll shows' in Melbourne and Brisbane and her work is now represented in various books, including *Vital Decade* by Geoffrey Dutton and Max Harris and *The Artist Craftsman in Australia* by Fay Bottrell.

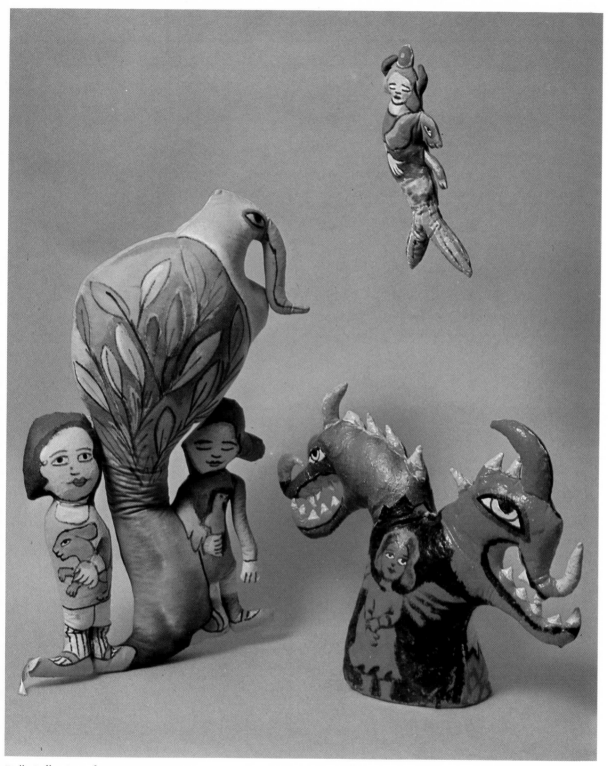

*Dolls* Collection of Marzena Birnberg.

# ROSS MOORE

Ross Moore was born in Broken Hill, New South Wales,
in 1954.

An English Honours student at Monash University,
Victoria, he fondly recollects the outback scenes around his
home town. His subjects are influenced by his great love for
animals and plants and a strong interest in human shapes which
he portrays with insight and humour.

Ross Moore is a compulsive painter who works when the
mood takes him and finds that he does not have to construct
his paintings intellectually. Although he works slowly, the
overall composition needs no alteration, even after weeks at
his task.

A spiritual experience brought about his first painting. He
describes his work as 'windows into another world, and into
himself' – he sees each as a living part of himself, rather than
a viable object.

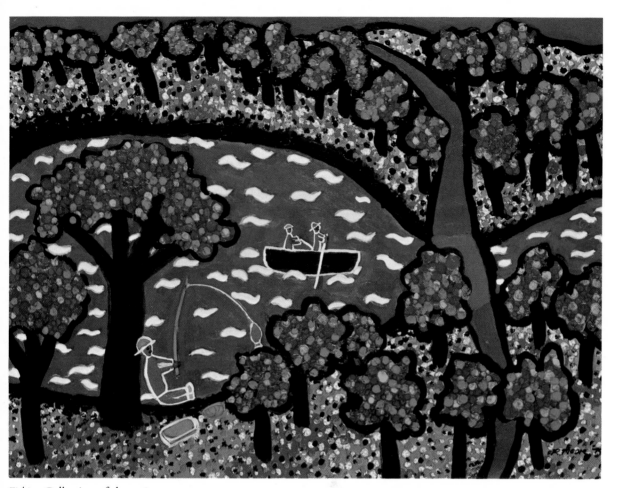

*Fishing* Collection of the artist.

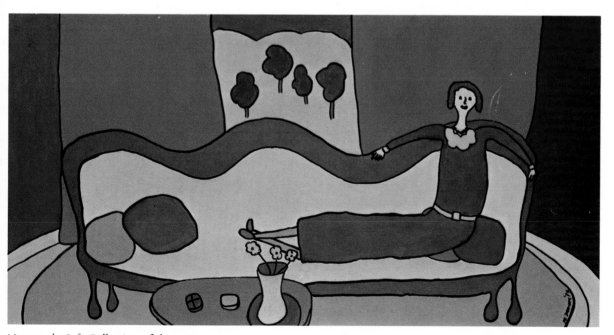

*Nora on the Sofa* Collection of the artist.

# SUE NAGEL

Born in the Victorian Wimmera district in 1942, Sue Nagel lived for a time near Macedon in Victoria.

At seventeen she was a champion golfer and the youngest person ever to win the Royal Melbourne Golf Club Associates' Championship.

Sue Nagel was interested in art at school, but she never had formal art lessons. She took up serious painting while recovering from a long illness.

She has had numerous successful exhibitions and her work is included in collections in Hong Kong, London, South Africa, the United States of America, including Hawaii, and Germany.

She loves the outback which she has come to know through extended holidays and also through the books of Ion Idriess, her favourite Australian writer.

As subjects for her paintings, Sue Nagel uses again and again the arid, dry, red soil of the outback and its people and animals. These make her paintings so very Australian. She also makes use of legendary Australian figures such as Daisy Bates.

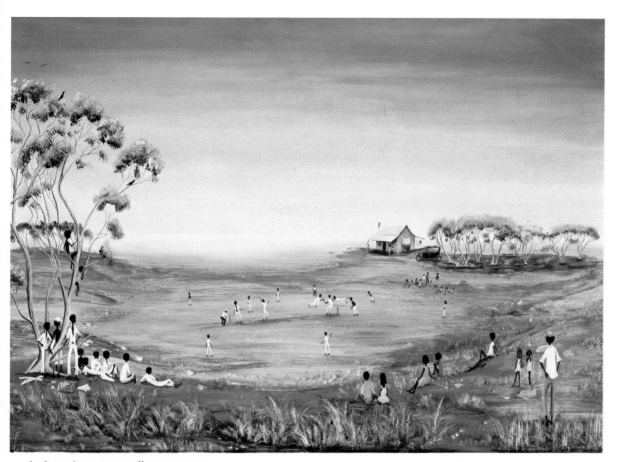

*Outback Cricket* Private collection.

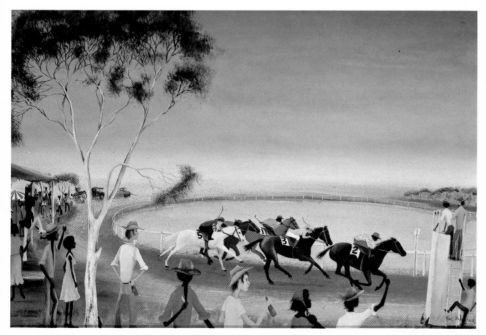

*Picnic Race Meeting at Wilcannia* Private Collection.

# DICK ROUGHSEY

Dick Roughsey is about fifty-three years old and an elder of the Lardil tribe of Mornington Island in the Gulf of Carpentaria.

He is a man of many talents and as an artist he has exhibitions in Canberra, Sydney, Toowoomba and Cairns. As an author he has two successful books to his name. *Moon and Rainbow* is the story of his tribe and *Giant Devil Dingo* is a mythical story straight from the legends of his Aboriginal heritage.

Dick Roughsey is a past chairman of the Aboriginal Arts Board and a member of the Institute of Aboriginal Studies.

He lives with his family, either on Mornington Island or in Cairns, and he keeps in close contact with fellow artist Percy Trezise.

Dick Roughsey's paintings are signed with his tribal name of *Goobalathaldin*.

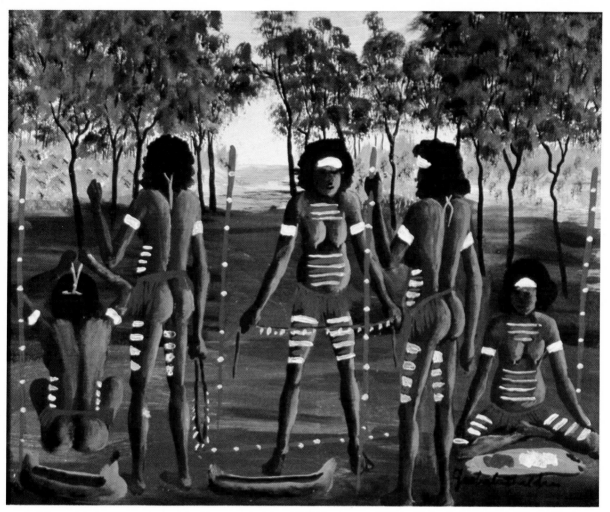

*Women Decorating for Initiation Ceremony – Mornington Island* Collection of Barry Stern Gallery, Sydney.

# HUGH SCHULZ

Hugh Schulz was born in Innisfail in Queensland in 1921. He moved to Broken Hill in New South Wales at a very early age.

He is a self taught artist, working in the slow and meticulous style so typical of the naif.

He once prospected for gold on the Western Australian goldfields and now works in the lead, silver and zinc mines of Broken Hill.

His paintings, depicting the arid, ochre country of the outback also show his love of wildlife and his involvement in the lives of the characters he has met on his travels.

Hugh Schulz is a member of the 'Brushmen of the Bush', a group of painters who live in Broken Hill and hold exhibitions in all Australian capital cities as well as in London and Rome. They have raised funds for charities amounting to more than $40,000 since their formation in 1975 and their members include miners, anthropologists, professional men and full time artists.

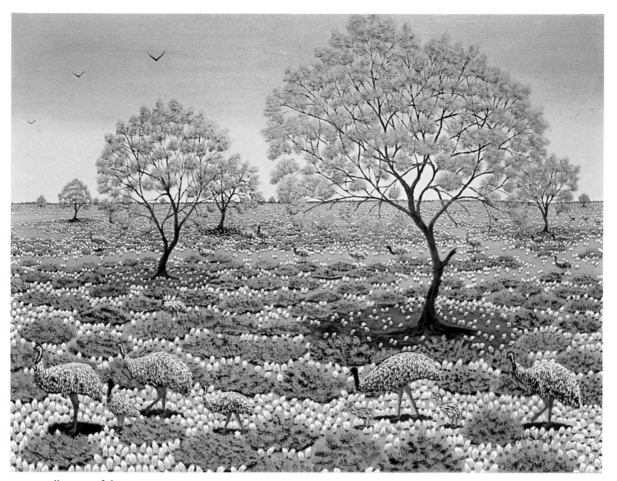

*Emus* Collection of the artist.

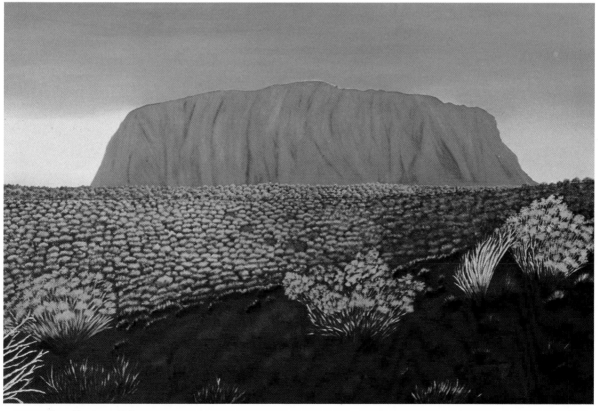

*Ayers Rock* Collection of the artist.

# ERIC STEWART

Eric Stewart was born in 1903 and died in 1970.

His paintings were not discovered until after his death. Artist, Clifton Pugh found the first of them in a second-hand dealer's shop and he subsequently located others in various parts of Victoria.

Eric Stewart was a nightwatchman with the Post-Master-General's Department. He learnt a little about painting when he was in hospital recovering from tuberculosis. He tried to conform to traditional techniques until about 1967 when he became ill once again and was told that he had not long to live.

From that time, Eric Stewart's painting style changed; a change which produced his powerful pictures of Aboriginal legends. He was inspired by Roland Robinson's book, *Aboriginal Myths and Legends*, which he seemed to understand instinctively and which he translated into painted epics.

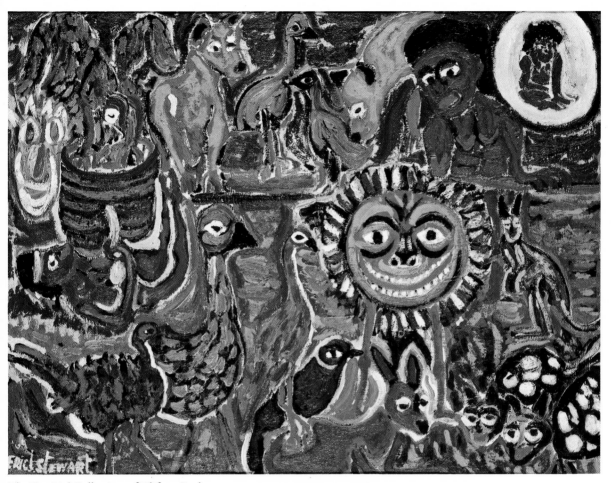

*The Fire Bird* Collection of Clifton Pugh.

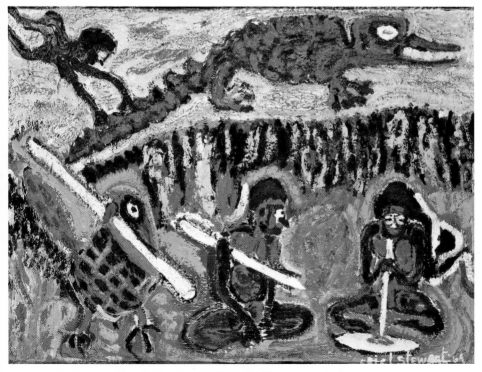

*Legend of Everlasting Water* Collection of Clifton Pugh.

# MILAN TODD

Milan Todd is a Yugoslav-born sculptor who lives in Melbourne.

He studied at L'École des Beaux Arts in Paris for three years before settling in Australia. He has had numerous one-man exhibitions and he won the Flinders Art Prize in 1973. He was an exhibitor in the Blake Prize for Religious Art in 1973.

Milan's Todd's uniquely simple style has the earthy quality of his native Yugoslav peasant art. His work expresses his great love for man and beast and birds and flowers.

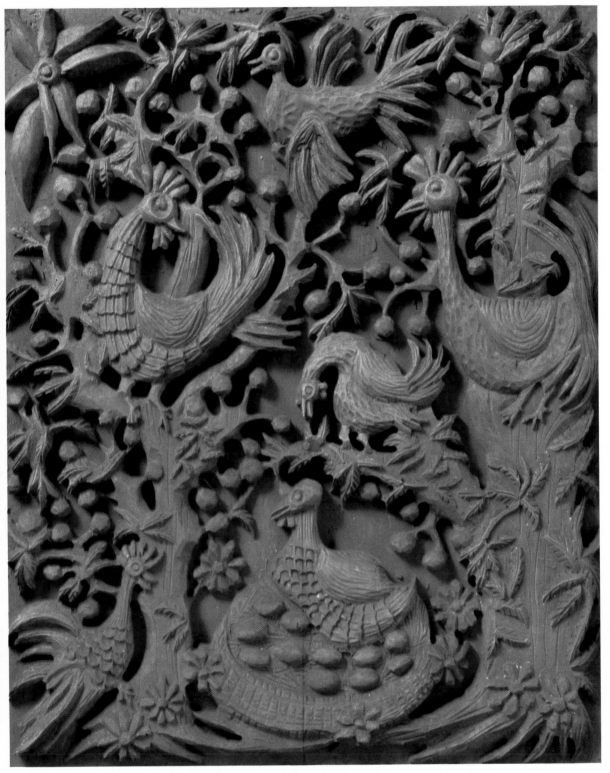

*Expectations — Carving in Queensland Beech* Collection of the artist.

# SELBY WARREN

Selby Warren was born in 1887 in Bathurst in New South Wales.

He worked at various occupations in the country, becoming adept in the skills of the shearer, rabbiter, miner and cutter of railway sleepers. It was this latter named occupation that gave him the inspiration and the detail for his most famous work, *The Sleeper Cutters*, which now hangs in the Australian National Gallery in Canberra.

Selby Warren is now regarded as one of the grand old men of Australian naive art.

He was promoted in his early days by Rudy Komon.

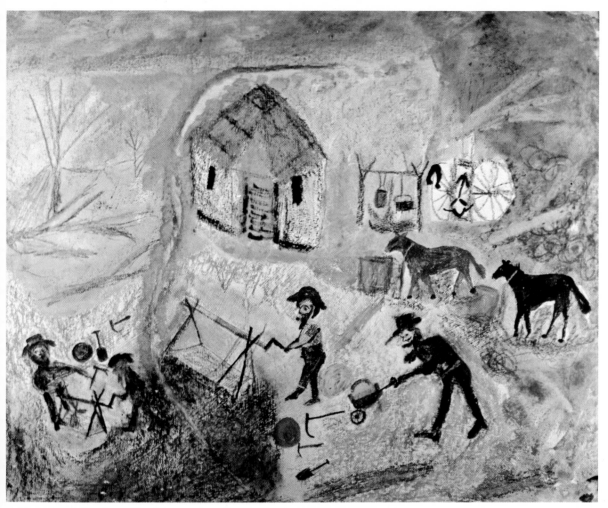

*Gold Mining* Collection of Rudy Komon Gallery, Sydney.

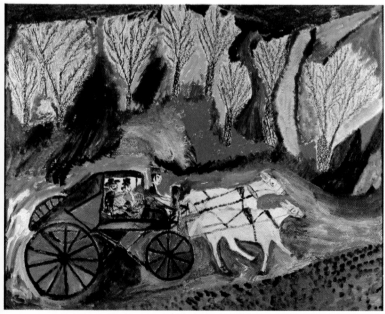

*Untitled* Collection of Rudy Komon Gallery, Sydney.

# MAX WATTERS

Max Watters was born in Muswellbrook in New South Wales in 1936.

He is a self taught artist who began painting seriously in 1956. His first pictures were mainly figures and portraits, but now he mostly does landscape work. He switched from portraiture to landscape painting in 1962.

His landscape subjects are usually taken from the area he knows best – the Upper Hunter Valley in New South Wales.

It is his usual practice to make sketches on the spot, using craypas and pencil, and these he develops into full paintings in his studio. Watters uses a colour range to suit his particularly bold interpretations and employs a certain amount of artistic licence in regard to colour. It is this boldness of approach which has set him apart from other naifs.

Max Watters is represented in the National Collection in Canberra, the Newcastle City Art Gallery, the Wollongong City Art Gallery, the Muswellbrook Municipal Collection and private collections in Australia, the United States of America, the United Kingdom, Germany and Singapore.

His work is now handled by his brother, Frank Watters, who first encouraged him to take up painting.

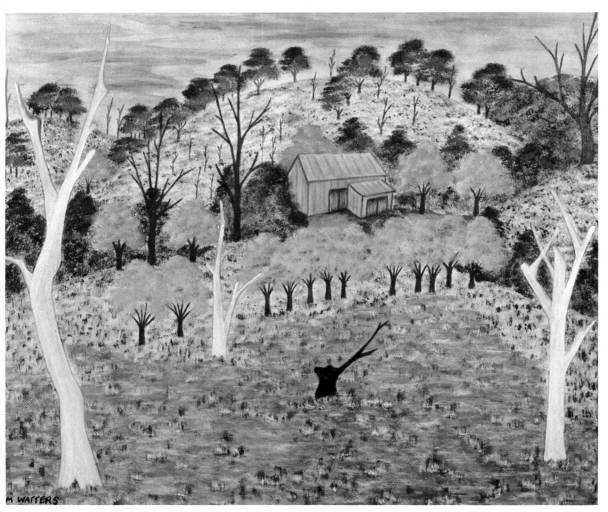

*View from Lemington Road* Collection of Frank Watters Gallery, Sydney.

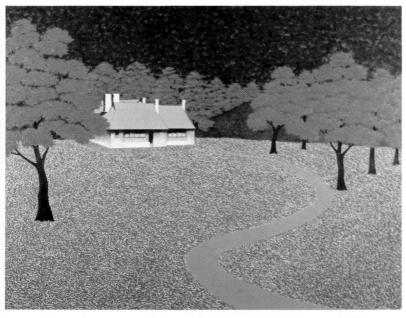

*House with Tanks, Antiene* Collection of Frank Watters Gallery, Sydney.

# W.E. (BILL) YAXLEY

Bill Yaxley was born in Melbourne in 1943 and spent his childhood in Shepparton in northern Victoria.

He has been painting for about twenty years. During this time he has supported himself as a gold prospector, a driller and a factory hand, travelling around Australia and later going overseas to Canada and the United Kingdom.

He also worked for a time in New Zealand, fruit picking, scrub cutting and prawning in various disticts.

With his family Billy Yaxley has now settled down on a fruit farm in Queensland, dividing his time between his trees and animals and the compulsion to record on canvas the country life around him.

He was encouraged in his art by John Maynard, Director of the Auckland Museum Gallery.

Painting has always been a celebration of Bill Yaxley's life – a life which now revolves around his farm and family.

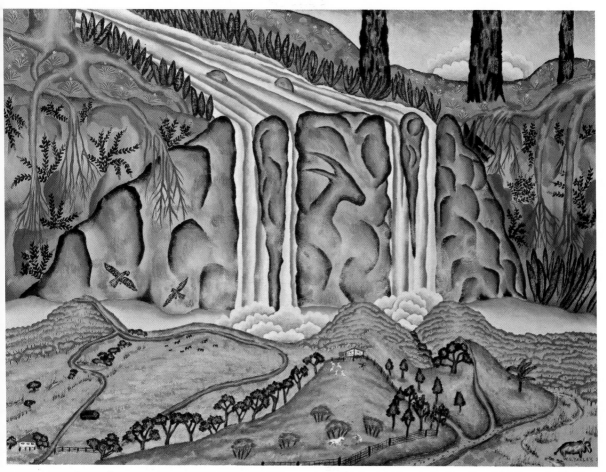

*Dingo in Paradise* Collection of the artist.

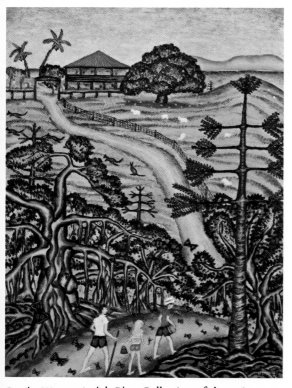

*On the Way to Andy's Place* Collection of the artist.

# THE BORDER LINE CASES

When preparing this book, I thought it would be easier to define 'border line cases' than the actual naifs as the criteria would be less strict and the choice enormous. It is this enormity of choice which now baffles me for the border line cases all touch, in some respect, my demarcation line from naive-surreal to naive-intellectual, from technically perfect-naive to childish-naive and, in fact, children's art.

For the sake of presentation and ease of reference, I shall simply pick at random a few of the most obvious examples of what I term 'border line cases' and ask the reader for under-standing if I have left out a favourite.

However, it is important to point out that all the artists mentioned here have one thing in common. They have an inordinate curiosity about many aspects of life – a hunger for adventure, both physical and intellectual. They are men and women for all seasons.

# ANNE GRAHAM

Anne Graham is a Viennese-born Melbourne artist who came to Australia in 1939.

Her varied career has included the making of art films, fountains and murals as well as a period of art study in Europe with Enrico Greco and Oscar Kokoschka.

Anne Graham has always been deeply interested in humanity which she portrays with kindness and humour. Satire sometimes appears in her work, revealing that side of her which is the sophisticated intellectual.

In her paintings she consistently uses the simple shapes and colours associated with European peasant art, retaining the power of direct statement and a youthful freshness of vision.

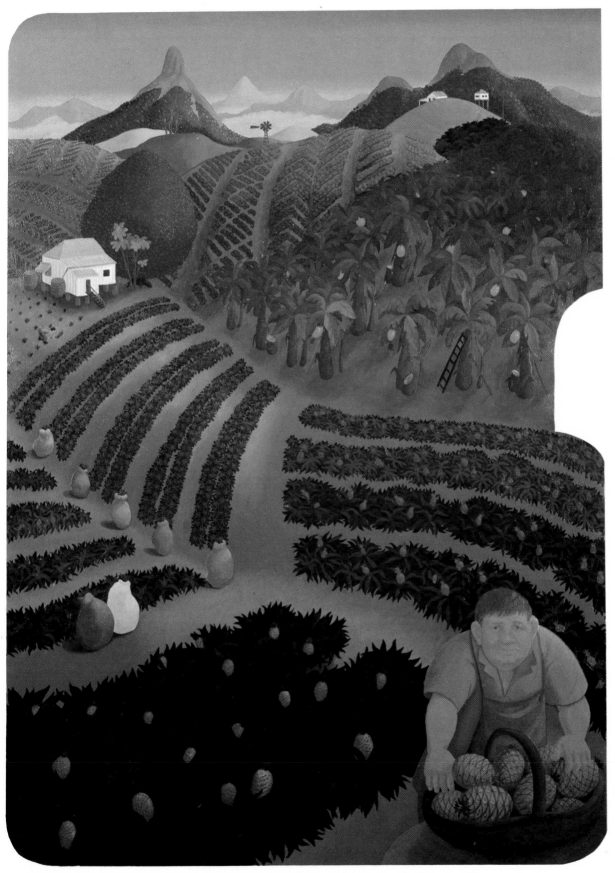

*The 6th Month, Australia* From a series of twelve panels. Collection of the Queensland State Gallery.

# KEVIN CHARLES (PRO) HART

Pro Hart was born in Broken Hill in New South Wales in 1928. He worked in the mines of his home town before starting to paint as a young man.

He was discovered by Kim Bonython in 1962 and promoted through Barry Stern in the eastern States.

Pro Hart has become internationally known through his successful exhibitions at the Qantas Galleries in London in 1973 and 1976 as well as through exhibitions in Rome, Israel, Hong Kong, Singapore and other South-east Asian cities.

He lives and works in Broken Hill. Here he has built an ambitious studio-gallery which houses both his art and music collections, including three organs.

He is a compulsive collector of art, silver, old fire-arms and coins and his interests span painting, music, the occult, pyramid power and every subject in between.

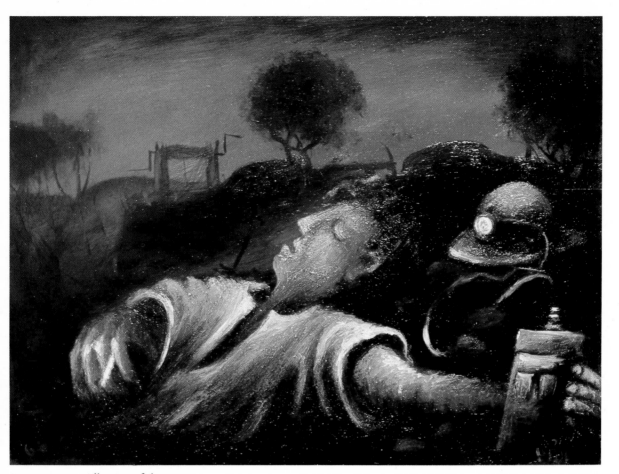

*Resting Miner* Collection of the artist.

# BERNARD HESLING

Bernard Hesling was born in Yorkshire in England in 1905.
He arrived in Australia in 1928.

He is a man of many talents; a successful author of humorous autobiographies, a cartoonist, an art critic and a painter.

Hesling started painting in Paris after meeting such famous artists as Vlaminck and Léger. He is best known for his use of vitreous enamels and it has been through his exhibitions in this medium that his works have become well known in all Australian capital cities.

His subjects range from formalised illustrations on enamel plates, which he has produced in thousands, to historical and sociological studies meticulously created to present infinite detail.

In Bernard Hesling's work there is always that humour and *joie de vivre* which instantly appeals to his audience.

*Dreamtime of the Computors* Private Collection, Perth.

# JUNE STEPHENSON

June Stephenson and Anne Graham are not only close friends, but their work has very definite similarities which can be traced to the influence of George Bell early in their careers.

Both women are meticulous observers and recorders of life around them.

In June Stephenson's case, imagination is an added factor. She weaves a fabric of fact and fantasy with the skill of an oriental story teller.

Her involvement with portraits and figure compositions shows her great skill as a draughtsman. It is this aspect of her work that won for her the Hugh Ramsay Portrait Prize as well as other prizes for figure drawing and still life.

She is concerned with the ugliness and barrenness of our modern cities on the one hand and on the other the romantic voluptuousness of nudes in their Rousseau-like settings. In all her paintings there is a strong adherence to geometry and pattern.

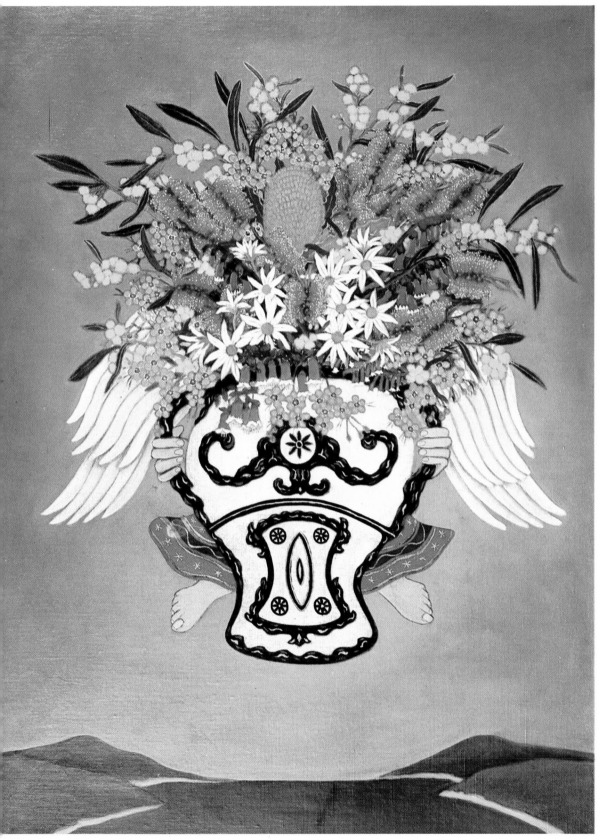

*Flowers for the Angels* Collection of the artist.

# PERCY TREZISE

Percy Trezise was born at Tallangatta in northern Victoria.

He has led a rich and varied life as an airline pilot, an historian, an explorer, an anthropologist, a writer and an artist. Sometimes he was many of these things at the same time.

In 1956 he moved to Cairns in Queensland where he discovered a special affection for tropical Australia. He is particularly fond of the country of the Cape York Peninsula.

Percy Trezise has written three books on Australia's north, *Quinkan Country*, *Rock Art of South East Cape York* and *Last Days of a Wilderness*.

He painted for a time with his friend, Ray Crooke, whose influence can be felt in his choice of colours and composition.

He is married and he and his family spend much time with Dick Roughsey and his family, both artists drawing upon the essence of primaeval Australia for their work.

I feel that Percy Trezise's paintings have many of the basic qualities of the naif, but there is also an intellectual finish which classifies this artist as a border line case.

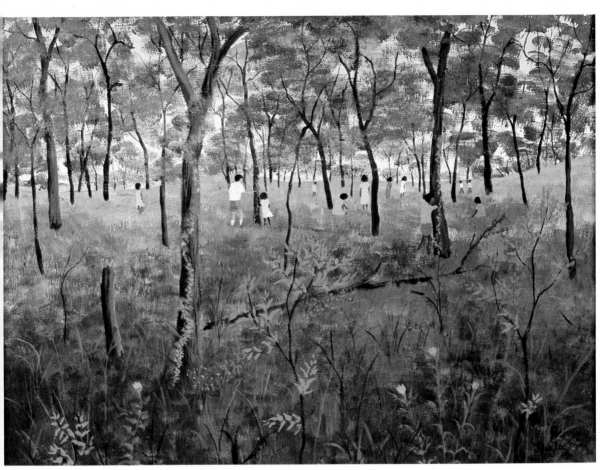

Title not known Collection of Kurt Barry, Queensland.

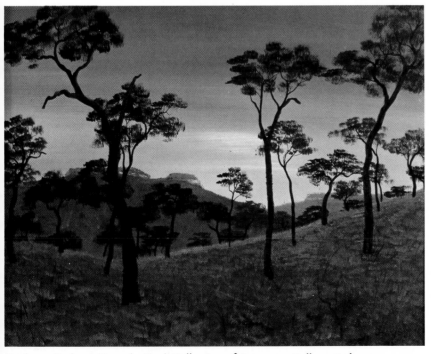

*Sandstone Peaks on Kennedy Creek* Collection of Artarmon Gallery, Sydney.

# MAYNARD WATERS

Maynard Waters was born in Sydney in 1936. He lived for a time around Broken Hill where his father was a construction worker.

He also worked as a construction worker for some years, travelling around Australia and spending time especially in Alice Springs and around Darwin.

Maynard Waters had a painting trip overseas before settling on the North Coast of New South Wales. He has had exhibitions all over Australia.

He paints in oils, often producing his works on a large scale. Invariably his subjects are the colourful sub-tropic vegetation around him and the inhabitants of remote country towns. It is his particular trait to always present his subjects with gentle irony and humour.

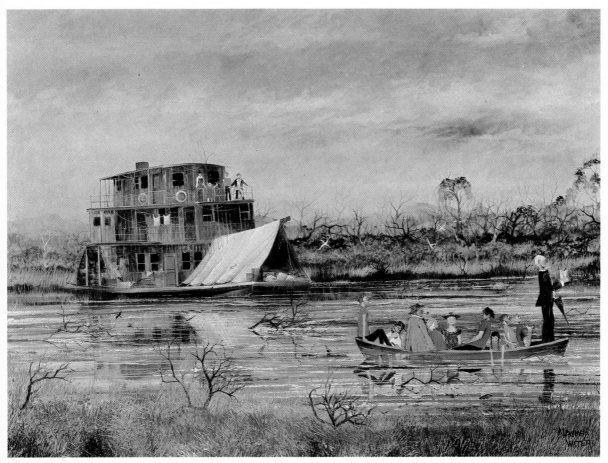

*Prayers on the Murray* Collection of N. Beller.